T0150712

CASTLE HILL

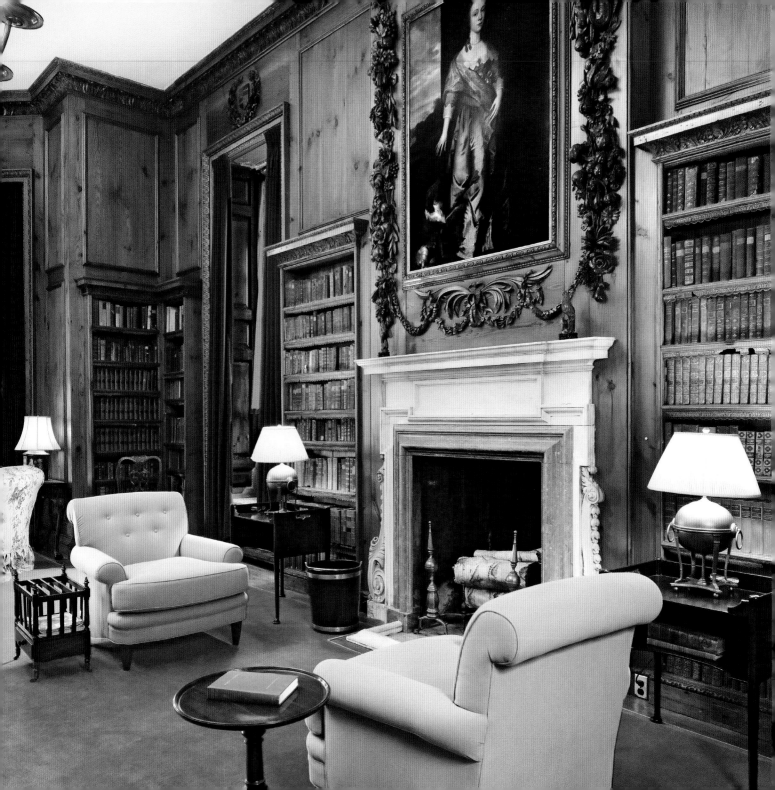

CASTLE HILL

on the Crane Estate

THE TRUSTEES

THE CRANE ESTATE

IN ASSOCIATION WITH

SCALA ARTS PUBLISHERS, INC.

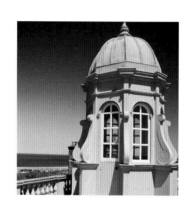

CONTENTS

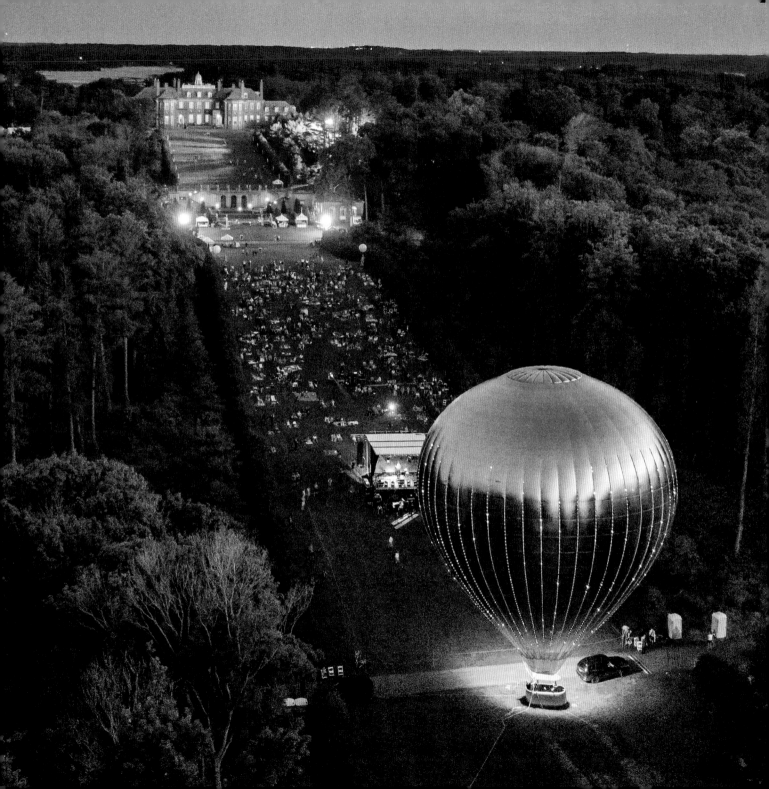

WELCOME

Overlooking Ipswich Bay, Plum Island Sound, and the Essex Bay in Massachusetts, Castle Hill on the Crane Estate stands in a position commensurate with its storied past, cultural richness, and natural beauty. The story of the estate and the family who made it their summer haven is an enchanting one. Today, the mansion and its gardens invite visitors to imagine living or working at the grand home of the Crane family, explore its designed landscapes, embrace its grand vistas, and enjoy its pristine beach.

Chicago industrialist Richard Teller Crane, Jr. (1873–1931), and his wife, Florence Higinbotham Crane (ca. 1871–1949), had spent several summers nearby. In 1909, Mr. Crane discovered the land at the end of a country road in Ipswich, and the spot would become the family's new retreat. Over the years, Mr. Crane acquired more parcels of land, eventually amassing 3,500 acres. The Cranes would go on

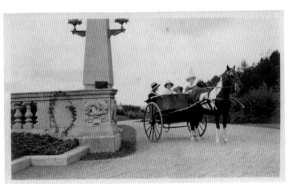

to transform the property into one of America's great estates, which included two mansions, twenty-one outbuildings, and designed landscapes. The grounds surrounding the mansion encompass a series of terraced gardens, including

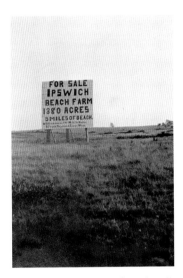

Opposite: Aerial view of Castle Hill during the installation of *New Horizon* by artist Doug Aitken in 2019.

"For Sale" sign on the future Castle Hill property, ca. 1909–10.

Members of the family arriving by horse cart, ca. 1913.

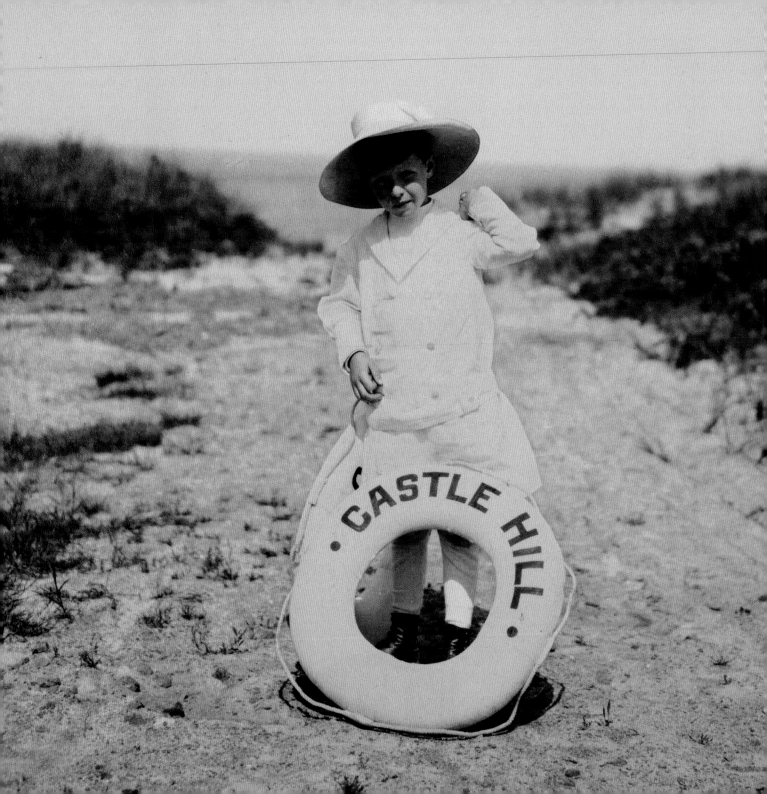

the Grand Allée, which offers a breathtaking vista to the sea. The plan, developed in partnership with some of the best landscape architects, designers, and engineers of the day, created what is now one of the most impressive designed landscapes of its kind.

In 1949, The Trustees of Reservations (The Trustees), which was founded in 1891 to preserve places of exceptional scenic, historic, and ecological value for public use and enjoyment, received Castle Hill as a bequest. The Trustees transitioned the family summer home into a cultural site open to the public with year-round attractions, including outdoor concerts, house and garden tours, special programming, and large-scale events. As part of its mission, The Trustees act as stewards to preserve and protect this special place, designated a National Historic Landmark in 1998.

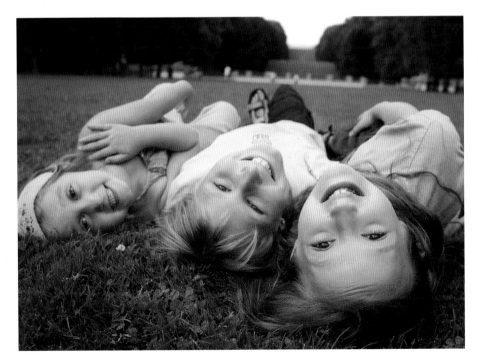

Opposite: Young Cornelius Crane at the beach, 1910.

Young visitors enjoying the Grand Allée today.

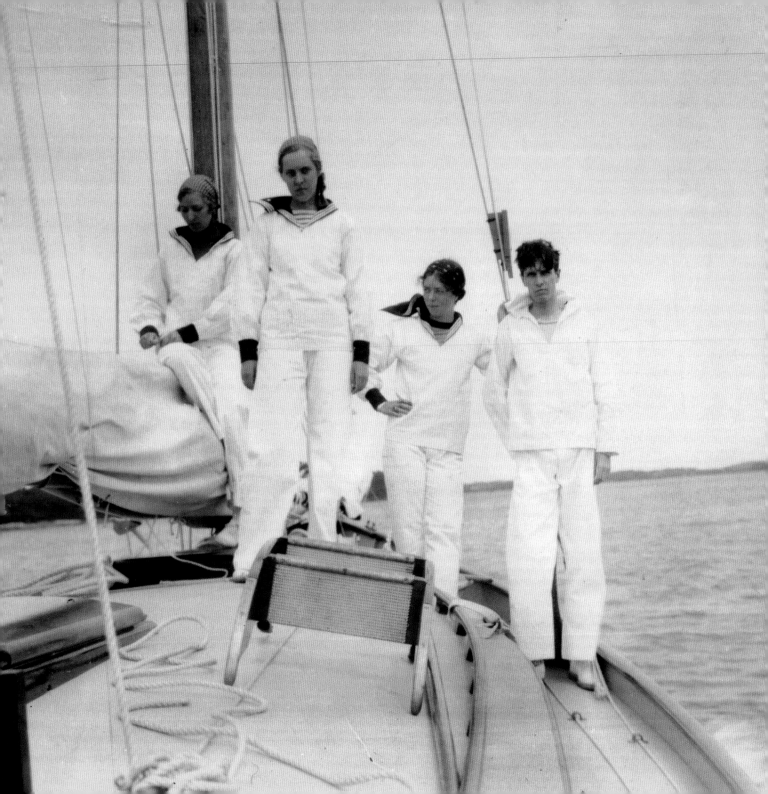

INTRODUCTION

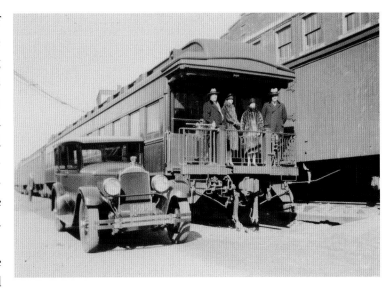

Richard Teller Crane, Jr., was one of America's great industrialists. He made his fortune running Crane Co., a leading manufacturer of pipes, valves, and fittings founded by his father, Richard T. Crane, Sr. (1832–1912), in 1855. As president from 1914 to 1931, Richard Teller Crane, Jr., expanded the company with a line of elegant bathroom fixtures. Although his primary residence was in Chicago, for his summer estate Mr. Crane chose the New England coastline.

An avid sailor, Mr. Crane brought his wife and children, Cornelius (1905–1962) and Florence (1909–1969), to the North Shore of Massachusetts each summer, where they rented seaside estates near such friends as the Fricks and the Vanderbilts. As the story goes, one day, while sailing in Ipswich, he spotted a dramatic hilltop perched above miles of pristine beach, saltmarsh, and woodland. This saltwater farm-turned-gentleman's farm was for sale, and Mr. Crane purchased it in 1910. He continued to buy contiguous land, and by 1918 he owned some 3,500 acres. Between 1910 and 1928, some of America's most renowned architects, landscape architects, and artists would transform the site into one of the nation's great Country Place Era estates.

Opposite: Cousin Florence Higinbotham, Florence Crane, Sarah Shurcliff, and Cornelius Crane aboard the *Northern Light*, ca. 1928.

The Cranes' Pullman car *Nituna*, in which Mr. Crane traveled extensively to Crane Co. locations, ca. 1924–29.

Pages 12–13: Aerial view of Castle Hill.

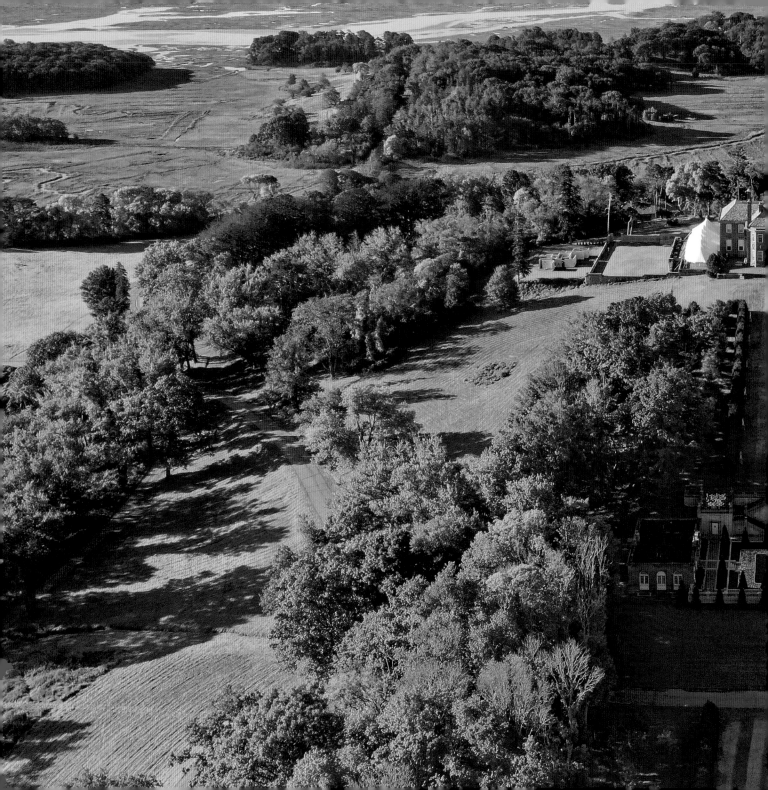

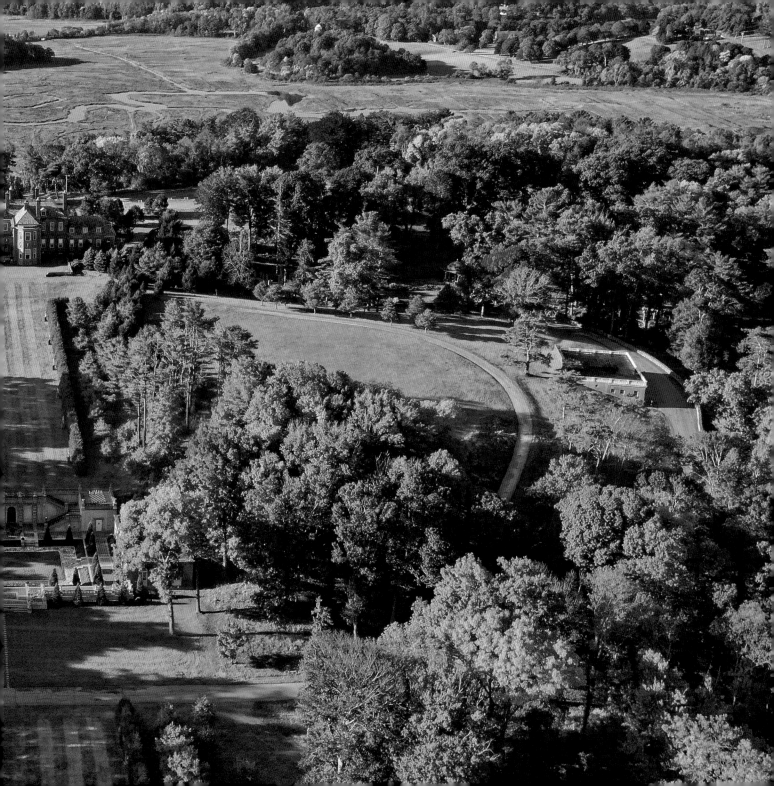

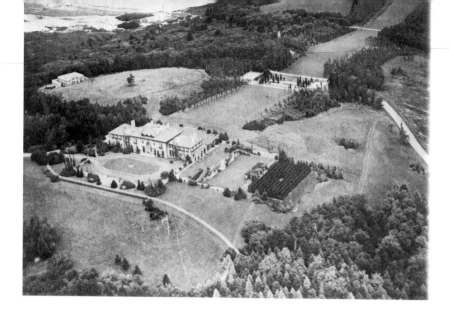

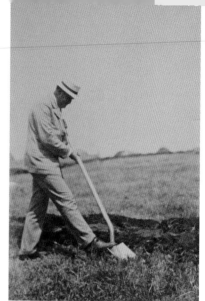

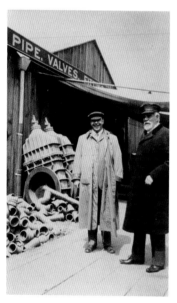

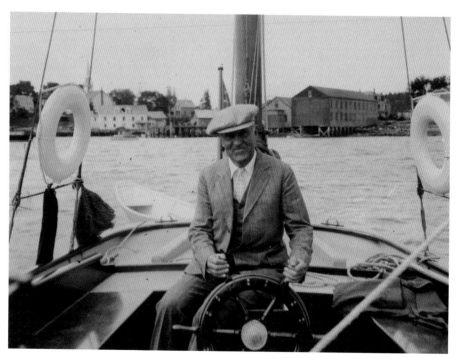

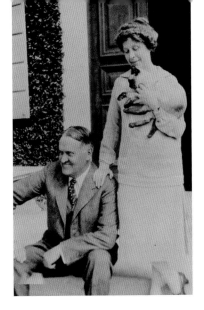

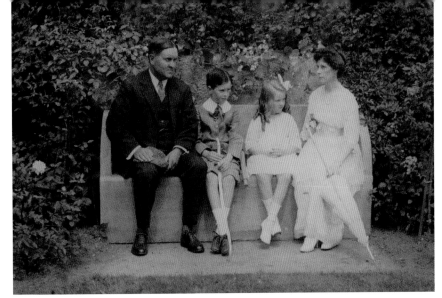

Sadly, Mr. Crane died on his fifty-eighth birthday, in 1931, just three years after the completion of the Great House. Florence and the children continued to summer in Ipswich until her death in 1949. Four years earlier, Mrs. Crane had generously given 1,000 acres to The Trustees and, in 1949, she bequeathed them the Great House and an additional 350 acres of land. In 1998, the U.S. Secretary of the Interior designated Castle Hill—the 165-acre parcel including the Great House—a National Historic Landmark. Today, the 2,100-acre Crane Estate comprises Castle Hill, Crane Beach, and the Crane Wildlife Refuge.

In 1904, Richard Teller Crane, Jr., married Chicago socialite Florence Higinbotham, whose father was a founding partner in the Marshall Field and Company department store and president of the World's Columbian Exposition of 1893. Their son, Cornelius Vanderbilt (named after Mr. Crane's dear friend), was born in 1905, and their daughter Florence was born in 1909.

Richard Teller Crane, Sr., founded R.T. Crane & Co. in 1855 as a brass and bell foundry. The business quickly grew to include pipes, valves, and fittings, which were essential for new machines, buildings, railroads, and bridges. Further expansion included steam heating, elevators, and fluid control. In 1890, the firm changed its name to Crane Co. From the beginning, the senior Crane pledged to conduct his business "in the strictest honesty and fairness . . . and to be liberal and just toward my employees." His fairness and generosity earned him much respect, and when Richard Teller Crane, Jr., took over as president in 1914, he followed in his father's footsteps.

Opposite, clockwise: Aerial view of Castle Hill, ca. 1920; Mr. Crane breaking ground on the estate, ca. 1910; Mr. Crane at the helm of *Northern Light*, 1927; Richard T. Crane, Sr. (right), in front of Crane Co. building.

Left–right: Mr. and Mrs. Crane with their Siamese cat, ca. 1926; the Crane family in the Rose Garden, ca. 1915.

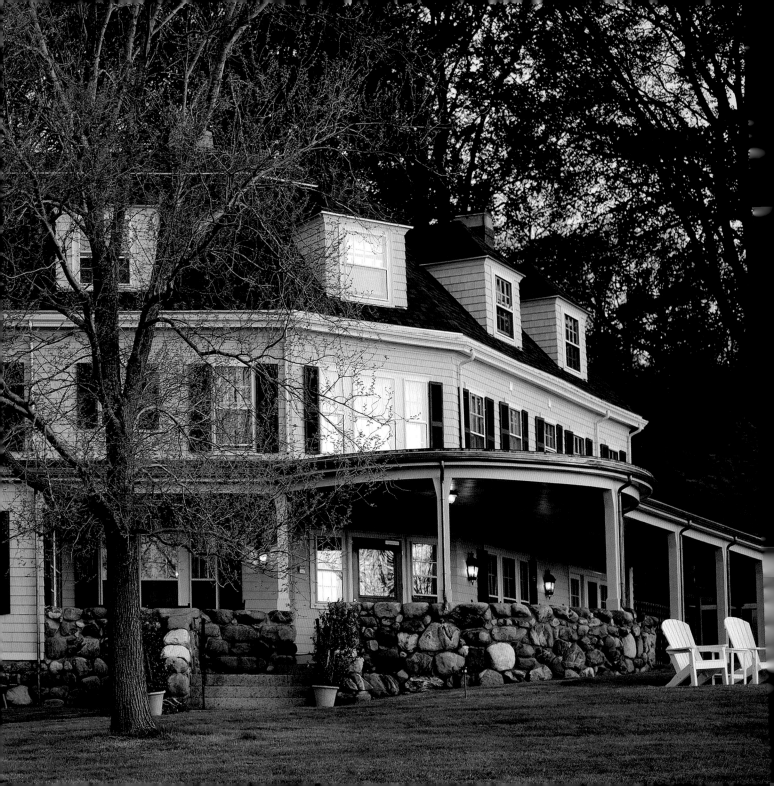

FROM FISHING TO FARMING TO ESTATE

Long before Castle Hill was developed by the English, the Agawam tribe of Native Americans occupied the land, which provided a rich source of fish, shellfish and game. When English settlers arrived in the 1600s, they farmed the saltmarsh hay, and the property remained a saltwater farm until the mid-nineteenth century. When John Winthrop, Jr. (1606–1676), son of the first governor of the Massachusetts Bay Colony, drew up a deed with Masconomet, *sagamore* (chief) of the Agawam tribe (died 1658), the land was referred to as "Castle Hill," named after a site in Ipswich, England.

In 1910, the Cranes purchased the property from the estate of John Burnham Brown (1837–1908), who had inherited the saltwater farm from his father, Manassah Brown (died 1882). A businessman and first president of the Chicago and Western Indiana Railroad, John Burnham Brown was the first to convert the property from a farm into a summer estate. He hired landscape architect Ernest Bowditch (1850–1918) to devise the road system at Castle Hill and re-designed the farmhouse at the base of the hill into a comfortable home in the Shingle style, in keeping with late nineteenth-century fashion. The Cranes resided in this house, known as "The Cottage," during the construction of their new mansion atop the hill. It later served as a separate guesthouse for visiting family. Refurbished by The Trustees in 2000, the building now graciously hosts visitors as The Inn at Castle Hill.

Opposite: The Inn at Castle Hill, formerly the Brown family cottage.

This sandstone plaque on the Great House exterior reproduces the deed between Agawam Chief Masconomet and John Winthrop, Jr. The name Castle Hill appears in local town records as early as 1634.

Pages 18–19: Aerial view toward the Crane Estate from the Atlantic Ocean.

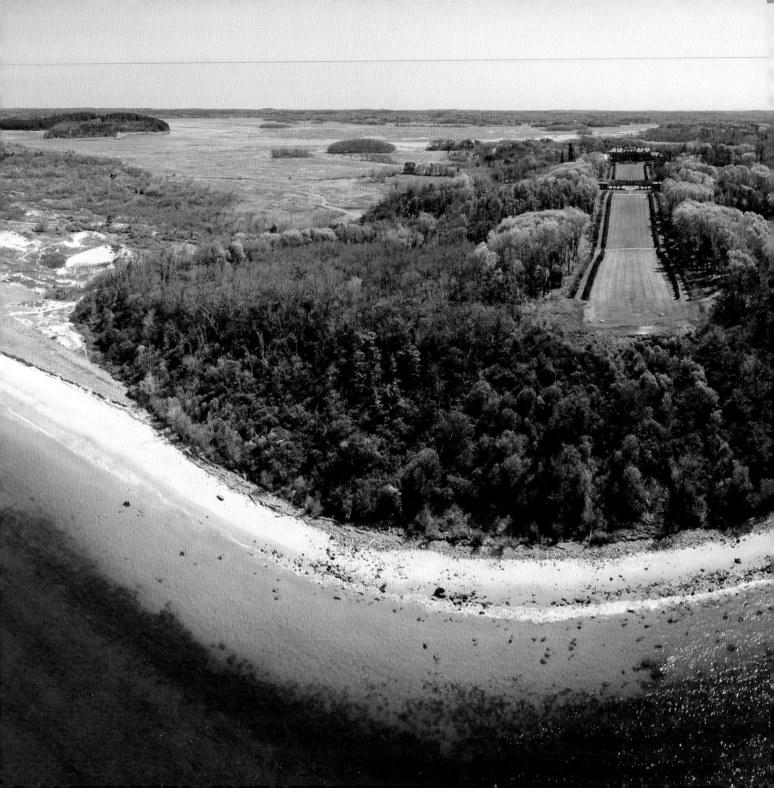

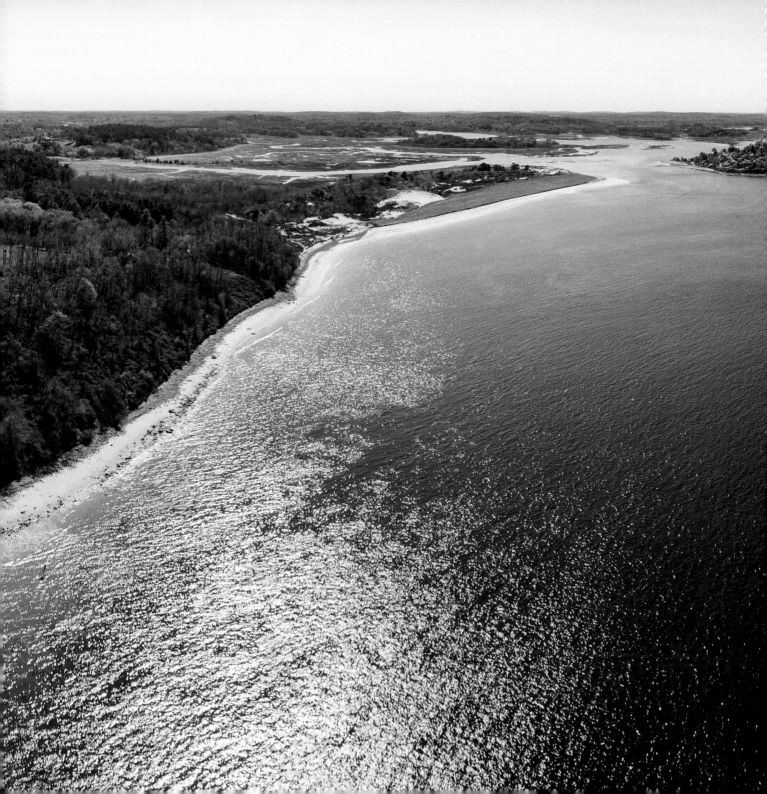

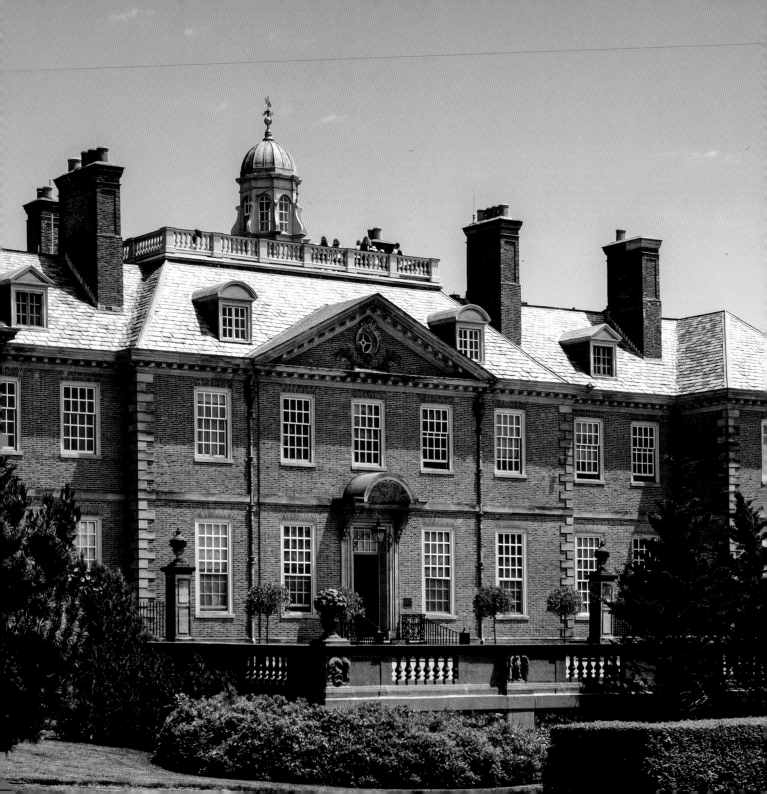

"A HILLTOP LOCATION" AT CASTLE HILL

Together with their expert team of architects, landscape architects, and engineers, the Cranes began to transform Castle Hill. In 1910, the firm of Olmsted Brothers—John Charles Olmsted (1852–1920) and Frederick Law Olmsted, Jr. (1870–1957), sons of noted landscape architect Frederick Law Olmsted (1822–1903)—was engaged to work on the property. They were tasked with siting the house and grading around it, reinforcing the existing road system, and designing a formal garden. The Boston architectural firm of Shepley, Rutan & Coolidge, which had recently designed the Crane residence in Chicago, was hired to design the summer mansion, along with a series of outbuildings and garden structures. As Frederick Law Olmsted, Jr., noted in 1909, Mr. Crane wanted "a hilltop location." That decision forever changed the landscape of Castle Hill.

Designed in the Italian Renaissance Revival style, the Crane mansion, or "Italian Villa," was designed with a stucco exterior and a roof of red clay tile. By 1911, the Cranes were spending the summer in their new home by the sea. Although the villa no longer stands, its Italian Renaissance Revival style remains in the outbuildings designed by Shepley, Rutan & Coolidge. These include a chauffeur's garage, the Casino Complex, structures in the formal or "Italian Garden," a barn complex at the base of the hill, and the balustrade surrounding the house.

According to family legend, the villa did not appeal to Mrs. Crane, who considered it cold and drafty. In 1924, the villa was razed and architect David Adler

Opposite: View of the south facade of the Great House.

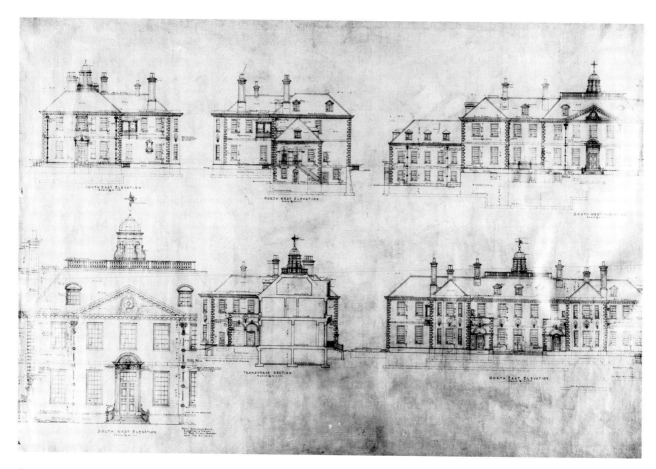

Great House plans as drawn by architect David Adler

(1882–1949) was hired to design a second structure, this one a Stuart-style brick mansion on the same footprint. The classically inspired mansion is in the manner of Sir Christopher Wren (1632–1723), and faced with pink Holland brick and sandstone trim. It commands a bold presence in the landscape and from the view out at sea. Known today as the Great House, it remains an icon in the landscape and Adler's masterpiece.

Adler was skilled at seamlessly combining eclectic styles with elegance and taste. He was well respected among Chicago's social elite and, in 1916, he designed the Cranes' winter home on Jekyll Island, Georgia. For the exterior of their new mansion at Castle Hill, Adler looked to late seventeenth-century English country houses, such as Ham House, in Richmond-upon-Thames, Surrey, and Belton House, in Lincolnshire. (Both are now owned by the National Trust, UK.) The south facade of the Great House resembles Belton House in its form and symmetry, as well as its distinctive cupola atop the roof. It is a five-bay, hip-roofed block with a pediment over three central bays. The north facade of the Great House resembles Ham House, constructed as a single, large hip-roofed block of thirteen bays, with symmetrical two-story projecting wings flanked by a flat-roofed porch on each side. Embellishing the wings and porches are thirteen cast-stone busts set into sandstone niches. Ham House facade has a similar design with stone niches but no busts.

With its strong symmetry and distinctive architectural features, Adler's fifty-nine-room mansion resembles an old English manor house. Yet construction of the Great House relied on twentieth-century industrial technology, such as steel framing, load-bearing bricks, and poured concrete floors. In a similar style, Adler also designed two brick gatehouses at the entrance to the property.

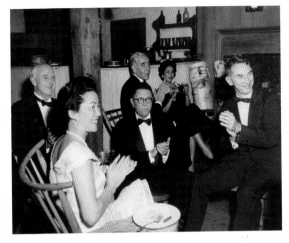

Miné and Cornelius Vanderbilt Crane (seated rear and center) entertaining in the Tavern, ca. 1960.

In 1959, Cornelius Crane, who had life tenancy on the estate, built "the Tavern" adjacent to his part-time home in the Cottage. Designed to resemble a seventeenth-century tavern, its interior incorporates a large First Period-style fireplace and heavy beams. A combination of antiques and custom Colonial Revival furniture completed the atmosphere. Cornelius and his wife Miné used the building as an entertainment space, and today it is part of The Inn at Castle Hill.

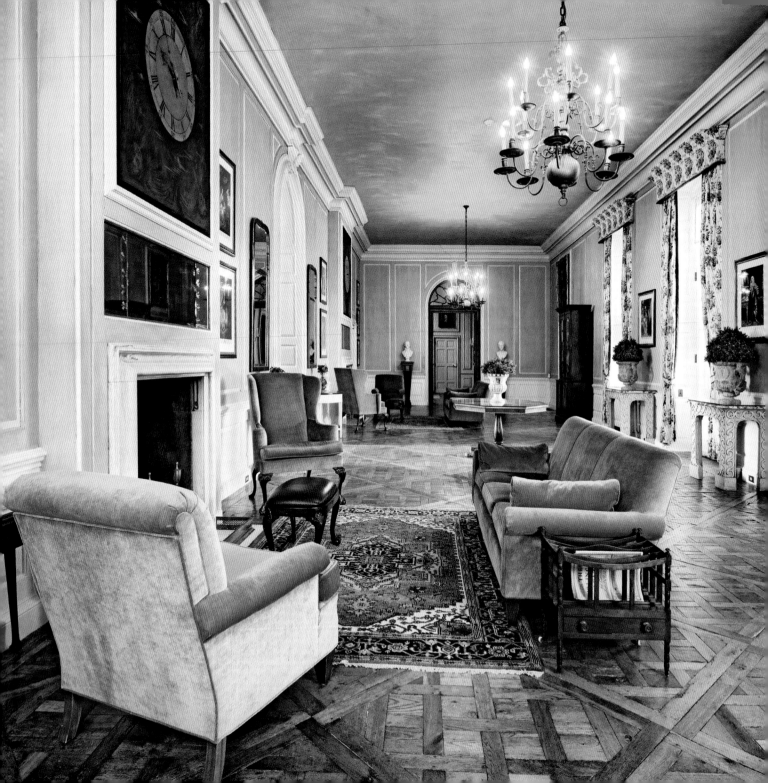

INSIDE THE GREAT HOUSE

From the moment one steps into the dramatic entry, finished with black and white marble inlaid with a brass Greek key frieze, Adler's design story unfolds. Each room has its own art form—a beautifully blended design statement comprising period and custom furnishings, antiques, and architectural salvage. The Grand Allée is the focus of many views, its vista beautifully framed through large windows and French doors, and from the North terrace.

Adler worked closely with Mrs. Crane to choose English furnishings and art for the home. The color scheme of many rooms reflects a palette of blue, green, and sand,

MRS. R. T. CRANE JR.

18th Century Sheraton Desk.
Arthur Vernay

250

David Adler supplied Mrs. Crane with photographic records of Great House furnishings for her approval, as documented in 1928 inventory cards. These archival photographs, complete with provenance information, are invaluable to the Castle Hill collection.

Opposite: The Gallery features Adler-inspired furnishings and works of art, and a view down the Grand Allée. In keeping with the English Country House theme, Adler installed antique oak flooring in the parquet de Versailles pattern.

to bring the outside in. To continue the look of an English ancestral home on the interior, Mr. Crane took Adler's suggestion to purchase architectural salvage from two English homes: Cassiobury House, former home to the Earls of Essex, in Watford, Hertfordshire, used in the Crane library; and a 1732 London townhouse, from 75 Dean Street, then marketed as the so-called Hogarth House by New York furniture store W&J Sloane. Its wood-paneled interiors were divided up and used in seven of the bedrooms, the dining room, and Mrs. Crane's sitting room.

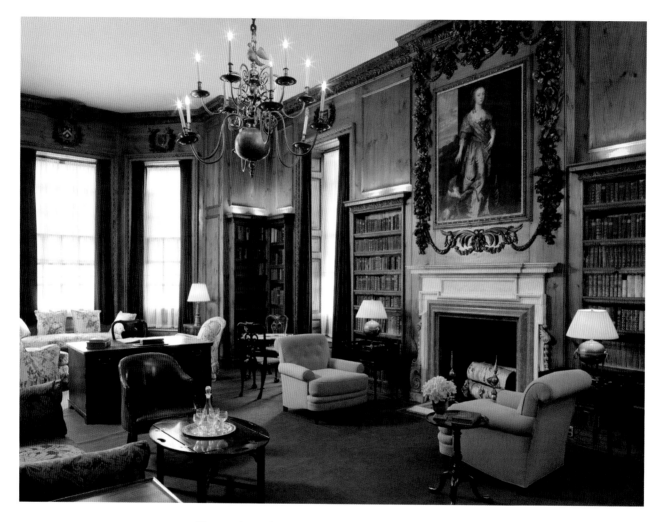

The wood-paneled Library was designed using architectural salvage from Cassiobury House, once the home to the Earls of Essex. The ornamental overmantel carvings are by renowned English Baroque sculptor Grinling Gibbons (1648–1721) and date to the 1670s.

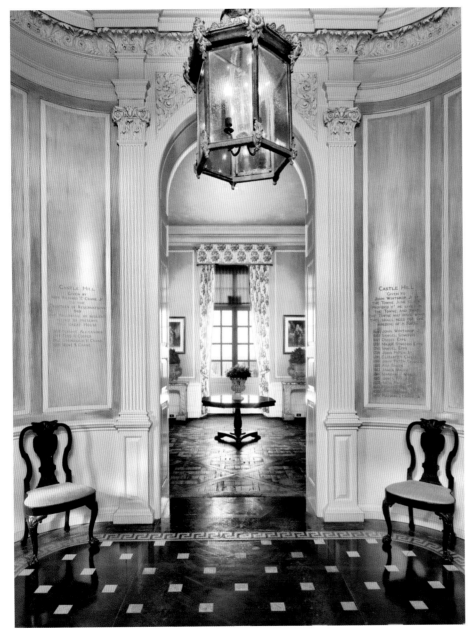

The Entry Hall, with its ornate floor and carved moldings, provides a view to the Grand Allée. A trademark of architect David Adler was his distinctive floor designs.

Outside the Library is the Rotunda, a circular room that features a mural by Chicago artist Abram Poole (1882–1961). The ceiling was inspired by one in Mantua, Italy, by the early Renaissance master Andrea Mantegna (ca. 1431–1506), and the oculus is faithful in concept, geometry, and perspective. The figures include Cornelius and Florence Crane (right), staff members, and the family's Siamese cat (below).

Opposite: For the formal Dining Room, Adler chose a Georgian neoclassical design with paneled walls, fluted columns, and an ornate mantel, all in grand proportions. The glazed jade-green paint reflects the original color scheme, which was popular in the 1920s.

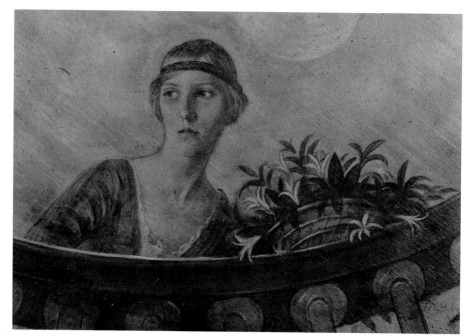

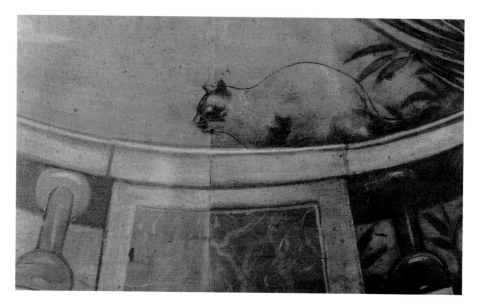

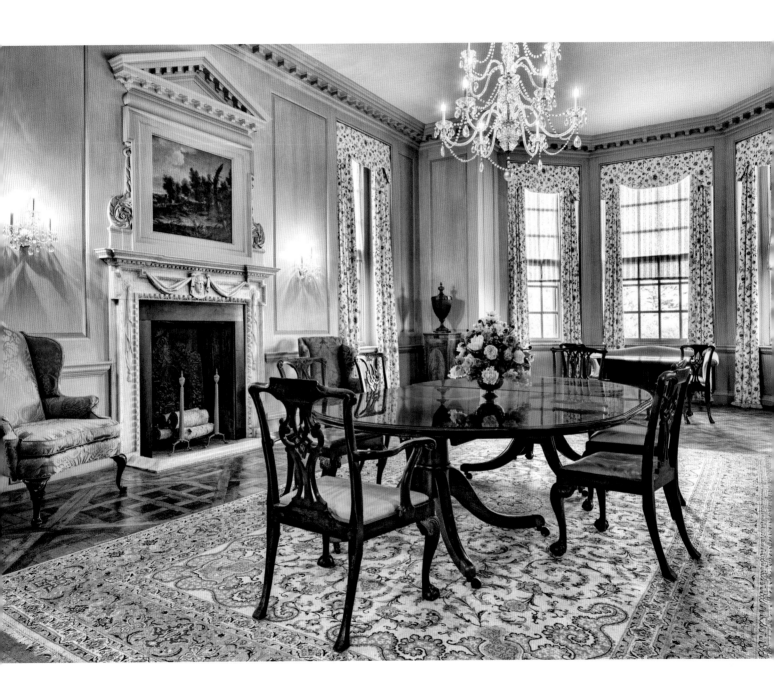

The grand staircase in the Stairhall is modeled after one from a 1732 London townhouse purchased as architectural salvage. Adler replicated the design but increased the scale to fit the Great House. The original staircase was donated to the Art Institute of Chicago.

Opposite: Mrs. Crane's bedroom features paneled interiors from the London townhouse, English furniture and needlework dating to the late seventeenth and early eighteenth centuries, and embroidered textiles.

The second floor consists of family suites, guest bedrooms, and sitting rooms, each named for particular design schemes, such as the Oak Room and the Chinese Room. Of course, all the _en suite_ bathrooms contain exquisite, state-of-the-art Crane fixtures. Recent research has revealed that Adler's sister, noted interior designer Frances Elkins (1888–1953), may have had some influence on the design of the Great House interiors as well.

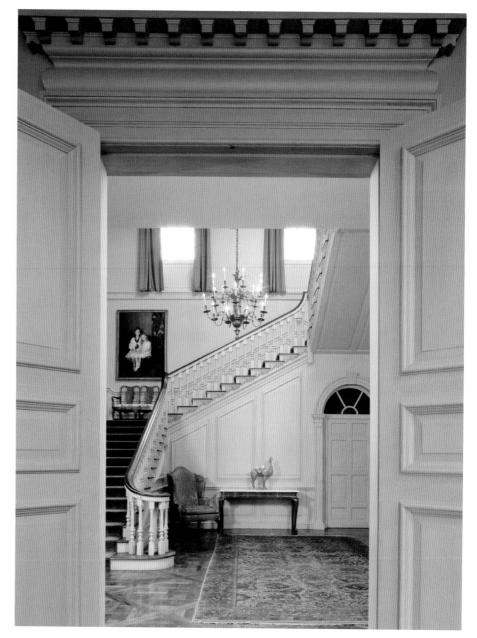

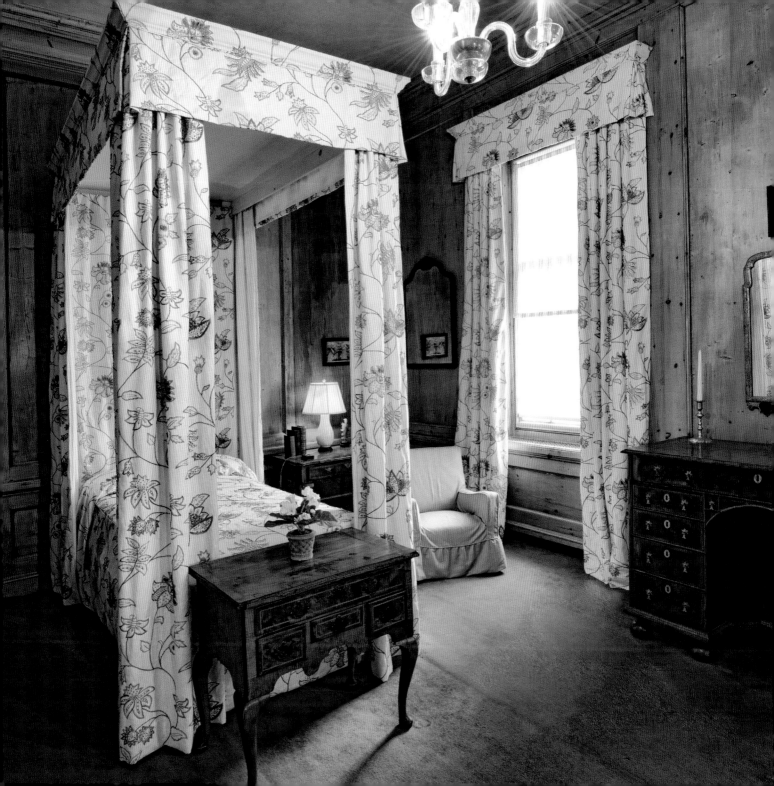

Cornelius and his sister Florence Crane by the cupola, ca. 1928.

The third-floor Ship Room, or Chart Room, housed the family's collection of nautical charts, books, and memorabilia, including models of Cornelius Crane's yacht *Illyria*, used for his Crane Pacific Expedition. A spiral staircase leads to a roof deck and cupola, which crowns the mansion.

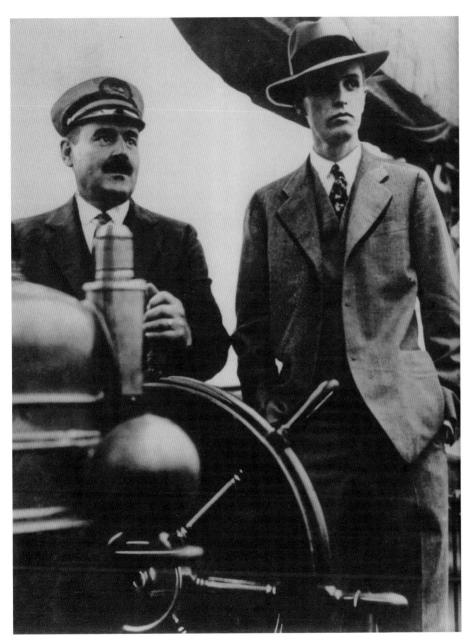

In 1928, Cornelius Crane launched the year-long Crane Pacific Expedition to the South Seas with scientists from the Field Museum of Natural History in Chicago, along with his friend and trip photographer, Sidney Shurcliff (1906–1981). They sailed aboard his new nearly 148-foot brigantine yacht, *Illyria*, commissioned for the trip. The expedition, sponsored by the Crane family, resulted in the collection of thousands of specimens, as well as rare photographs and film footage capturing the cultures, people, art, and animals of Papua New Guinea, New Hebrides (now known as Vanuatu), and many other Pacific islands.

Cornelius Crane setting sail for the 1928–29 Crane Pacific Expedition with Captain and Navigator Seldon B. Boutilier of Halifax, Nova Scotia. The *Illyria* was designed by Henry J. Gielow, Inc., and built in Lussin-piccolo, Italy.

SPOTLIGHT
Crane Bathrooms

When Richard T. Crane, Jr., took over as president of Crane Co. in 1914, the well-known manufacturing firm was already recognized for its high-quality valves, fittings, and pipes. By the 1920s, the younger Crane would focus on fixtures for luxury bathrooms. His vision to "Make America a Better Bathroom" paid off. He became the second wealthiest man in Chicago, and Crane bathroom fixtures became a sought-after brand with 190 branches and four national showrooms by 1930.

Mr. Crane ensured that his home was a showplace for his luxurious, state-of-the-art Crane bathrooms. While the family bathrooms were the largest and most elegant, each of the guest bathrooms had unique designs. Crane Co. had first introduced colored bathtubs in 1928, the year that the Great House was completed.

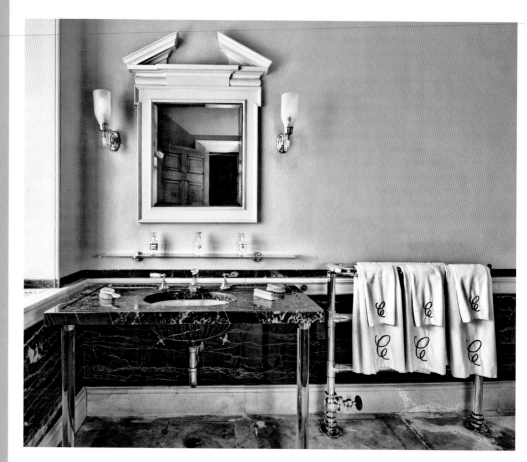

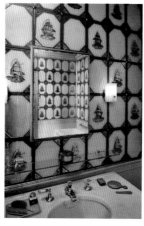

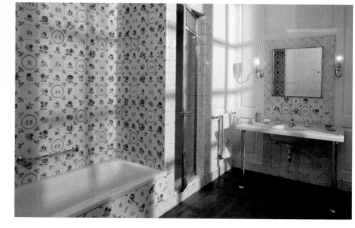

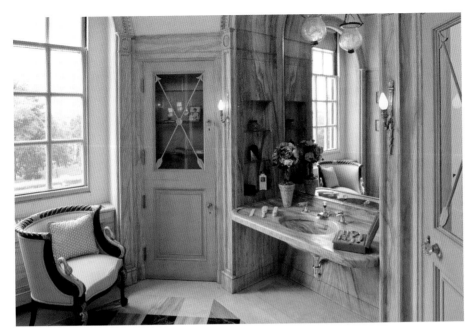

**Crane Co. was known for its
luxury bathroom fittings, but
it also mass-produced a line at
an affordable price. "Beautiful
Doesn't Mean Costly" was one
of the company's marketing
slogans.**

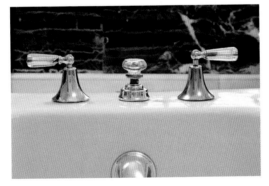

RUNNING CASTLE HILL

Like most of the wealthy of the day, the Cranes depended on a large staff to run their households and maintain the estate. According to census records, some of the Chicago staff traveled with the family to Ipswich, while others may have lived on the estate or in the town year-round. As many as one hundred maids, gardeners, governesses, chauffeurs, butlers, carpenters, and secretaries made up the staff. Many were immigrants, most commonly from Canada, Poland, Sweden, Norway, Ireland, and Scotland.

In the Great House, staff quarters were located off private hallways with tiled floors, and each room had a sink and built-in cupboards. The head butler enjoyed his own suite on the first floor, complete with a small office/lounge, bedroom, and bathroom. George Woodward is listed as a butler in the 1910 census, as is Ernest Hood in 1920 and Bruce Baden Golder in 1940; all came from England. Keeper of the estate's keys, the butler had a cabinet that held more than three hundred. The butler would have also overseen floral arrangements in the nearby Flower Room.

Research on the staff is ongoing. Records and photo albums given to the Trustees by descendants of Crane employees Anna Gustafson Erickson and Robert Cameron offer some visual glimpses into their lives. Erickson, born in Sweden in 1888, immigrated to the United States in 1910. She began working for the Cranes in Chicago in 1912 and came to Castle Hill with them that summer.

Opposite: Crane staff person Anna Gustafson sitting with two women and one man on stone steps near the chauffeur's garage and living quarters.

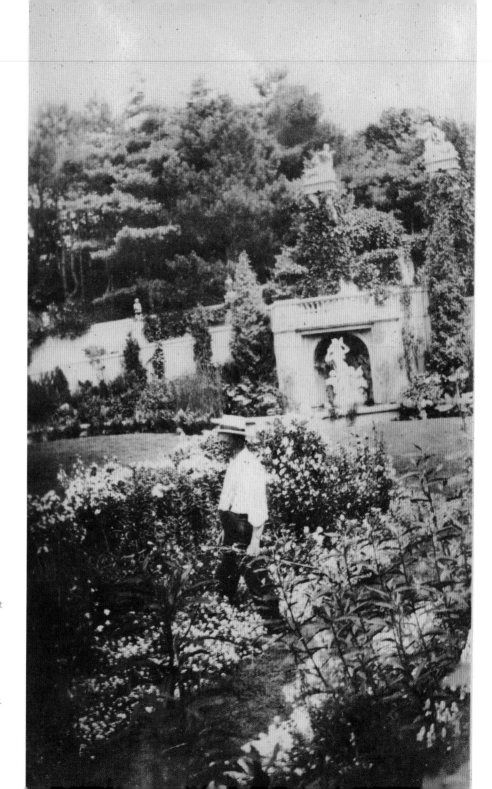

Castle Hill Superintendent Robert Cameron led a team in the care and maintenance of the gardens and grounds, and played a large part in the design of the gardens on the estate, notably the Italian Garden, where he stands proudly.

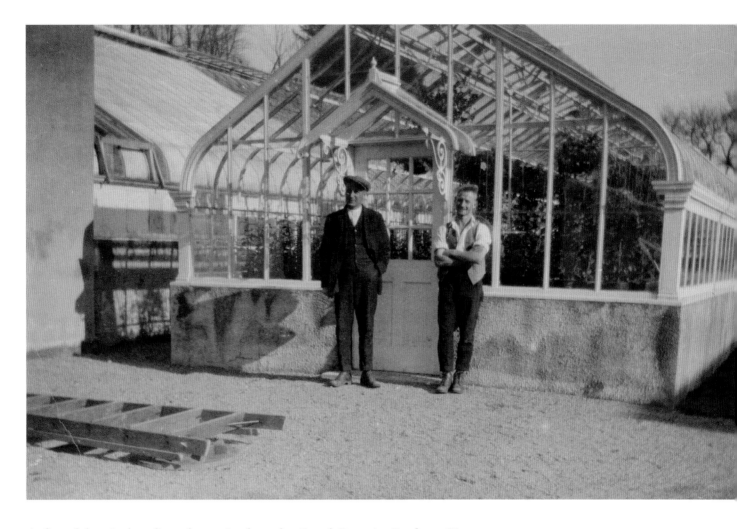

A famed horticulturalist who trained at the Royal Botanic Gardens, Kew, England, Robert Cameron was head gardener at the Harvard Botanical Gardens before coming to Castle Hill in 1919 as superintendent of the estate. When he retired in 1934, he talked about how Mr. Crane paid for him to travel across the country and to Europe to see great gardens, and "to get new ideas and new plants that could be worked into our scheme at Castle Hill."

Castle Hill Superintendent Robert Cameron and unidentified man in front of the greenhouses, ca. 1919–20.

The garage and chauffer's quarters ca. 1912–13.

In his memoir "Upon the Road Argilla," Cornelius Crane's good friend and neighbor Sidney Shurcliff mentions Stuart McRobbie or "Mac," who was one of two Crane chauffeurs at the time. According to Shurcliff, Mac was a Scotsman and a survivor of the battle of Gallipoli during the First World War. When the depression hit, the Cranes could only keep one chauffeur, so he left in 1930 to start his own filling station in Ipswich. He was very successful and went on to become a town selectman for several terms.

The original caption for this photograph reads "Ipswich jolly good crowd," perhaps hinting at the friendships that formed between members of staff.

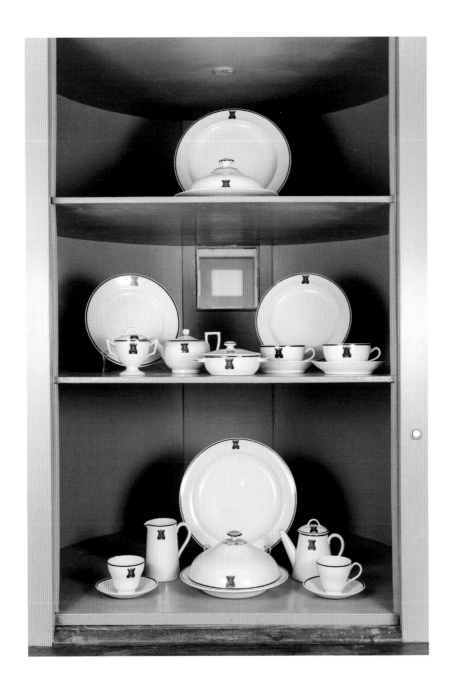

A revolving cupboard in the Butler's Pantry displays the family's Wedgwood china with the Castle Hill emblem.

The light-filled butler's pantry, which connects to the dining room via a swinging door, is a perfect example of how Adler's design accommodated form and function, and satisfied the goal of discreet service. A central stainless-steel table with a warming cupboard kept plates hot until service. A revolving cupboard connected to the kitchen. The nearby pastry room has a marble counter for rolling dough, a built-in flour bin, and a refrigerator room. Nearby, a walk-in safe held the family's silver. The staff dining area and screened porch were also located off the kitchen.

The Crane know-how is evidenced by the impressive, state-of-the-art technology on the property. This includes a 135,000-gallon underground cistern system to capture rainwater from the roof of the main house to irrigate the grounds; an internal Private Automatic Exchange (PAX) telephone and call-button system, located in a special telephone room; a trunk elevator; and a master clock and wind-indicator system in the Gallery. To alert the sailors of the house, smaller indicators in three family bedrooms and the Stair Hall were designed to light up to indicate the wind's direction and velocity. And during construction of the Grand Allée, water and power lines that fed the Casino Complex and provided water for the Allée's double rows of trees were painstakingly buried underground.

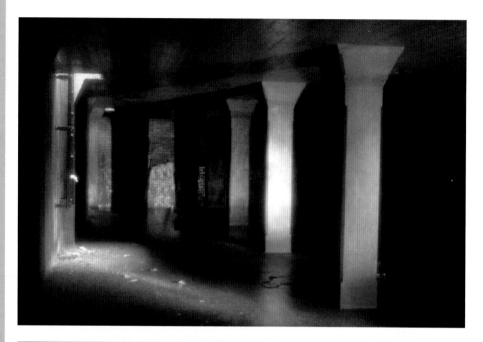

Opposite
Above: The cistern beneath the Bowling Green.
Below: Private Automatic Exchange (PAX) telephone and call buttons.

Clockwise: Wind Indicator made by Lord Electric Co., Boston; Casino under construction, 1914–15; The cast-lead downspouts on the Great House transfer rainwater to an underground cistern. With decorative details that mimic the library carvings, Adler found a way to combines art and technology in the Crane mansion.

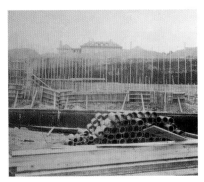

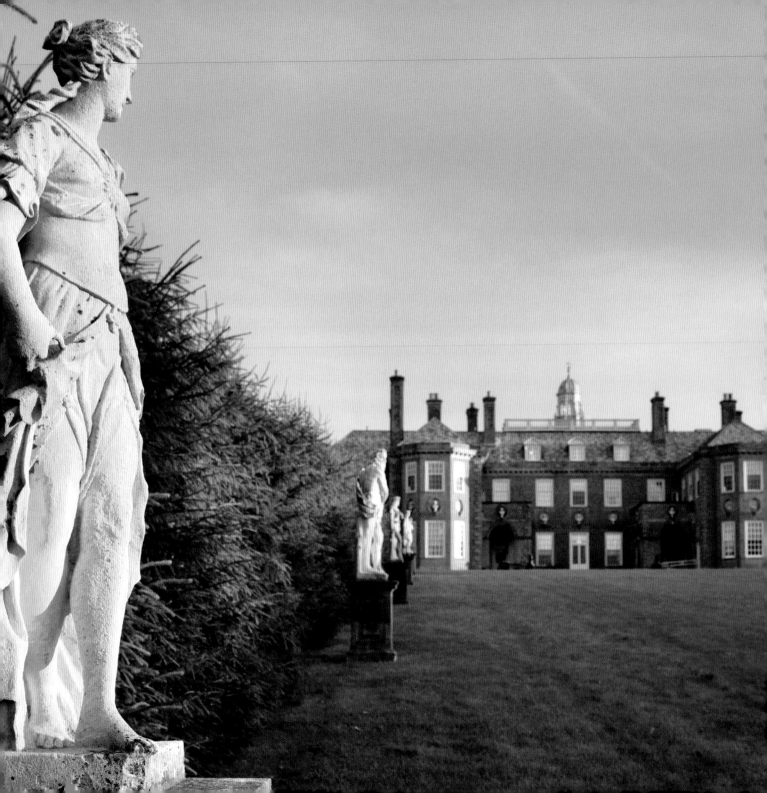

GARDEN ROOMS WITH A VIEW

The renowned landscape architecture firm of Olmsted Brothers sited and designed the approach to the Crane's mansion. The winding drive provided picturesque views at each turn, leading to a dramatic crescendo at the top of the hill.

The design for landscaping the back of the house came from summer neighbor and Boston landscape architect Arthur Asahel Shurcliff (1870–1957). His idea was to build out a rolling lawn, which not only created a magnificent view but also provided an attractive way to screen a pool and outbuildings. Reminiscent of the Boboli Gardens in Florence, Italy, the 2,060-foot undulating hill, initially called the "mall," is now known as the Grand Allée. Between 1913 and 1915, tons of earth were moved to create the slopes over three distinct hills, and woodland behind the Allée was cleverly appended to the design to create a seamless, textural, breathtaking focal point for the property. Statuary—common in Italian and English formal gardens—was added to the Allée, framing its manicured plantings.

Hidden from view of the Great House, the Casino (an Italian term for a small summer house) once served as additional entertaining space. A "bachelors quarters" to house male guests on one side faced a billiard room and ballroom

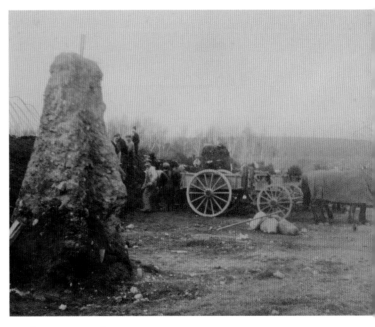

Opposite: The Grand Allée today with north facade of the Great House.

Grand Allée under construction, ca. 1913–15.

Pages 46–47: The Grand Allée today.

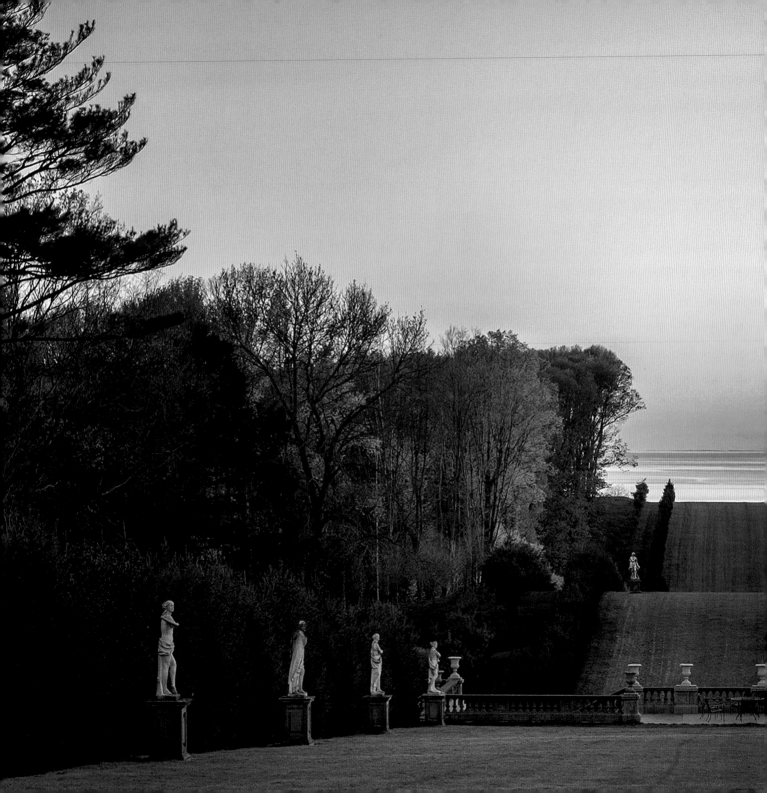

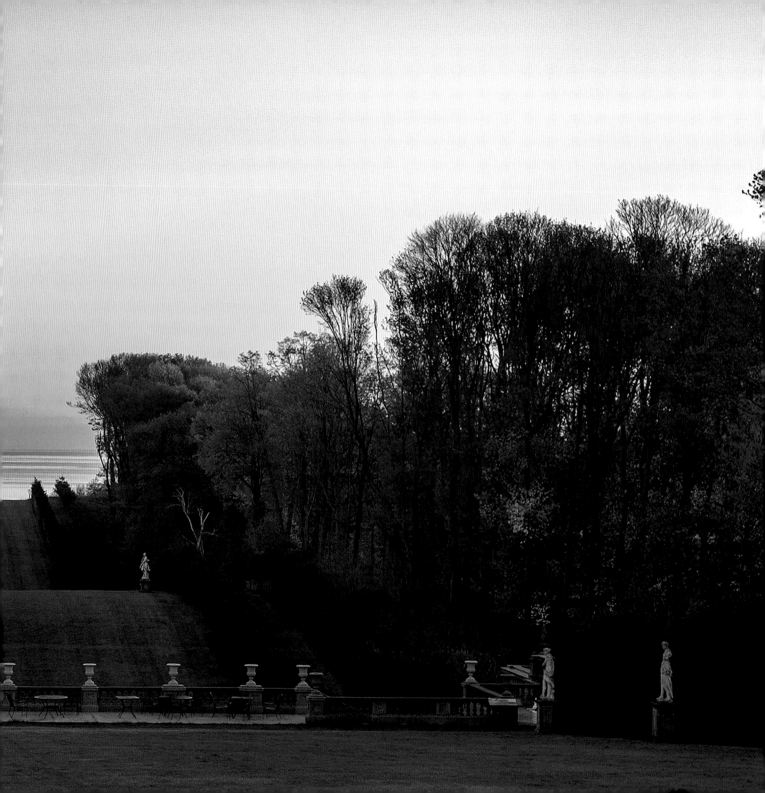

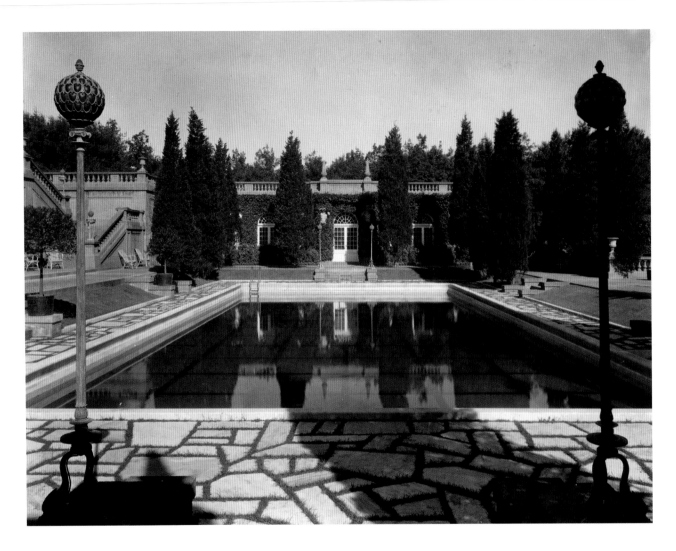

Casino Complex, 1920s.

on the other. The buildings once flanked a saltwater pool, now a lawn. The Casino Complex was designed in 1914 by Shepley, Rutan & Coolidge to complete the setting for the original Italian villa. It remains the best surviving example of the Italian Renaissance Revival style on the property.

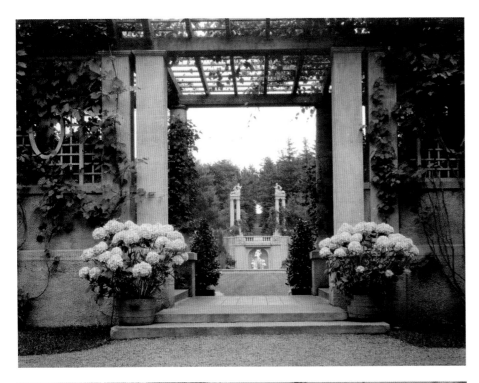

The Italian Garden, ca. 1920.

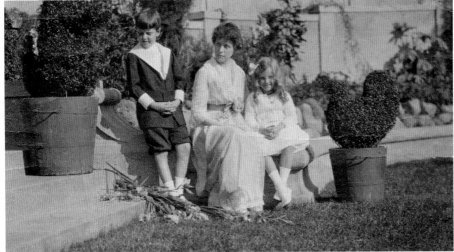

Cornelius, Mrs. Crane, and Florence in the Italian Garden, ca. 1913–15.

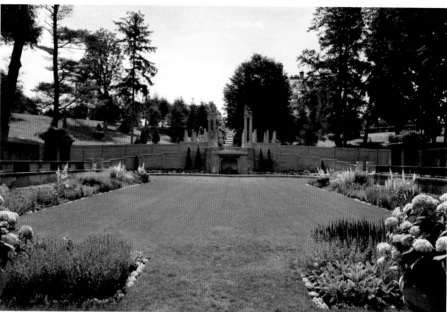

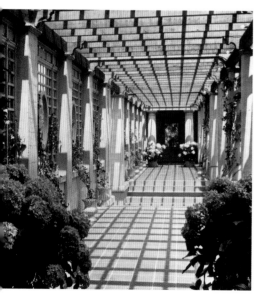

Working together with Shepley, Rutan & Coolidge, Olmsted Brothers constructed the formal or "Italian Garden" between 1910 and 1912. The design included a pair of octagonal covered structures called "tea houses" that punctuate the corners of the enclosed garden. Six symmetrical beds were filled with white, pink, and blue flowers. The terrace walls once had rambling roses, and pergolas were shaded by wisteria and fast-growing vines such as wild grape. A fountain at one end featured a marble work by American sculptor Bela Pratt (1867–1917).

The Wild Garden, which no longer exists, was across from the Italian Garden, and was also designed by Olmsted Brothers. It served as a transition between the formal garden and the untamed woods leading to the beach below.

As the Cranes continued to expand their number of garden rooms, Arthur Shurcliff was hired to design a circular Rose Garden, a Vegetable Garden, and a hedge maze. Family and friends also played tennis, croquet, and other lawn games on the sunken bowling green on the east side of the house. Grassy terraces with stairs led to this recreation area.

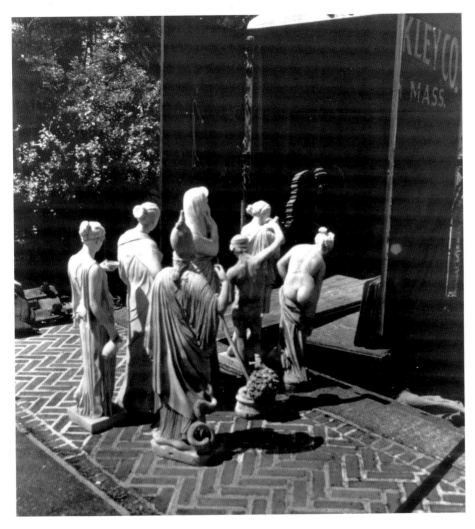

Garden statuary from the Casino Complex was sold at the auction of Florence Higinbotham Crane's estate. Most of the contents of the Great House, outbuildings, and garden areas were sold at the three-day Parke-Bernet auction at Castle Hill, held June 29–July 1, 1950.

Opposite: Views of the Italian Garden today and in ca. 1913.

SPOTLIGHT

Art in the Garden

At Castle Hill, architects collaborated with important contemporary artists to integrate sculpture into the landscape.

On the north terrace, facing the Grand Allée, *Griffins* by American sculptor Paul Manship (1885–1966) guard the home. As a gift to Mr. Crane from some "3600 old employees" of Crane Co. upon the completion of the Adler house in 1928, these mythical creatures allow us to connect the estate to the man behind it. Art Deco in style, this streamlined pair of sculptures also helps date the house to its own time. Manship, perhaps best known for his *Prometheus* fountain (1934) at Rockefeller Center, created these modern cast-lead sculptures to look like patinated bronze.

The cast-stone works in the Italian Garden by Johan Selmer-Larsen (1876–1969) were inspired by the seaside location. A pair of mermaids top the double columns

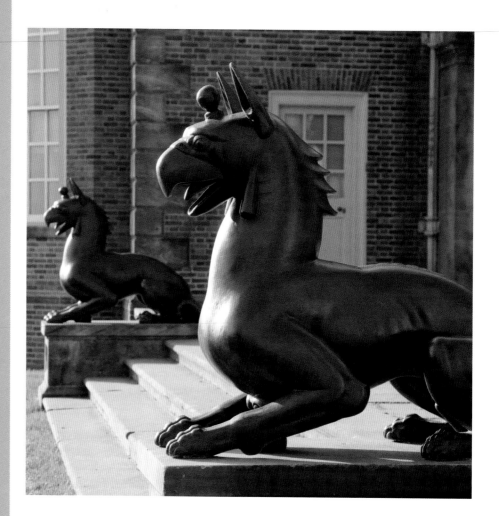

Paul Manship's *Griffins* (1928) were gifts to Mr. Crane "to guard his home at Castle Hill"; relief sculpture of seahorses designed by Johan Semer-Larsen for the Italian Garden balustrade.

Opposite: The focal point of the garden was Bela Pratt's *Iris* (1916), a 7-foot white marble sculpture. Mermaids atop the columns are by Johan Selmer-Larsen, working for the Olmsted Brothers.

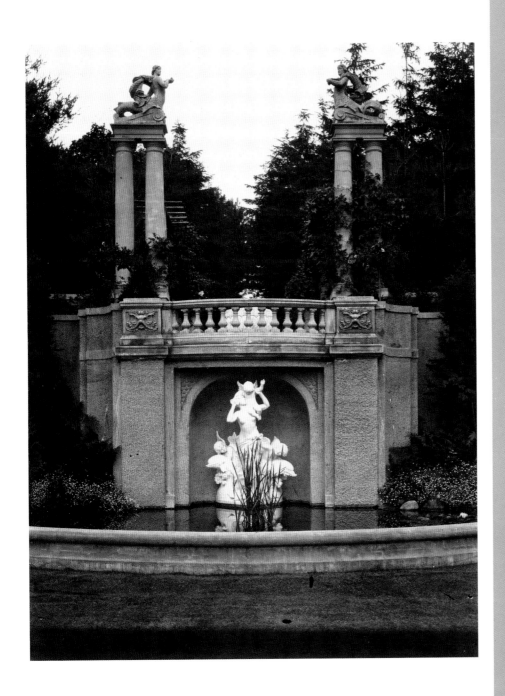

above the fountain pool, and reliefs featuring seahorses, dolphins, and mythical sea creatures are incorporated into the decorative balustrade. He also designed the masks, or "grotesques," above the pool area, a decorative element typical of Italian Renaissance design. Selmer-Larsen worked with Olmsted Brothers for more than four decades and taught at the Massachusetts Institute of Technology.

The focal point of the Italian Garden was *Iris* (1916), also known as the Rainbow Fountain, a 7-foot white marble sculpture by Bela Pratt. It was sold at auction in 1950. Dolphins at the base would spray water, creating a rainbow effect in the afternoon light. Pratt, the protégé of Augustus Saint-Gaudens (1848–1907), was a prolific artist and teacher in Boston during his short life.

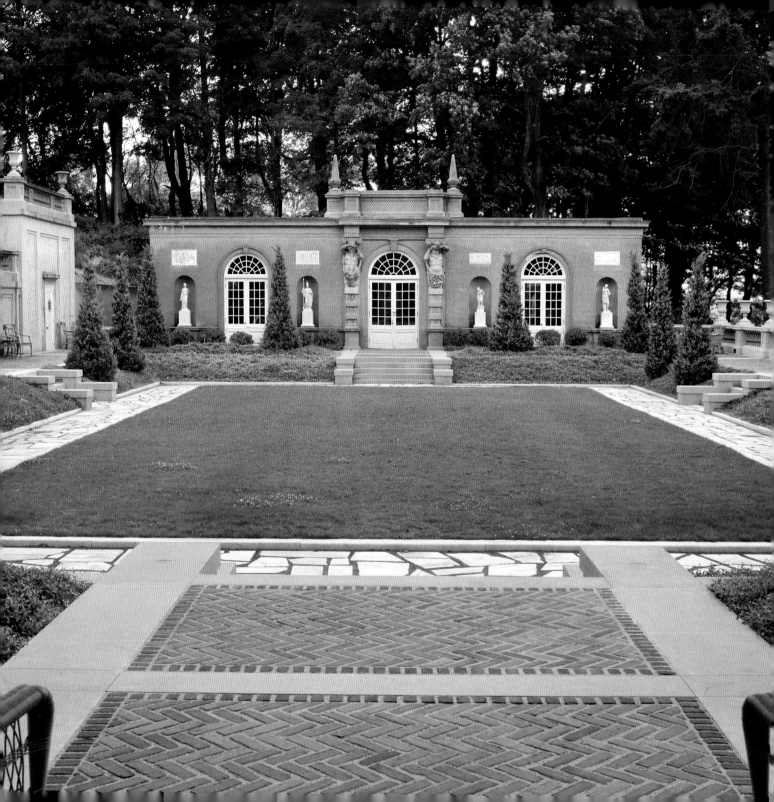

PRESERVING A NATIONAL LANDMARK

As owners and caretakers of the estate, The Trustees focus year-round on the evaluation of the property at Castle Hill. Today, after many recent historic preservation projects, the home and grounds look much the same as they did when the Cranes summered here.

A fundraising campaign supported the talents of curators, artisans, and preservation experts to restore, refurbish, and replant the estate. Some seven hundred unhealthy trees that lined the Grand Allée were replaced, and the statues that line the undulating lawn were conserved. The Casino Complex and Italian Garden underwent extensive restoration, both to the buildings and the landscaping.

In an effort to create a truly authentic experience for visitors and a better sense of the 1928 period style designed by David Adler, the curatorial team has put much effort into restoring the interior, as most of the original Crane furniture was sold at auction in 1950. Thanks to the generosity of extended Crane family members, many of the mansion's original furnishings have recently returned to the Great House.

Draperies and bed canopies in documented fabrics have been researched and recreated, paint colors and glazes for walls duplicated, and artisans have been called upon to conserve or reproduce original furniture and wallpapers. Conservation of original Crane collection objects—whether sculpture or wall-

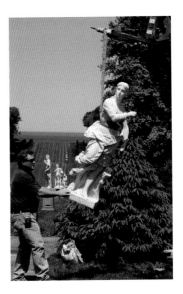

Opposite: The newly restored Casino Complex in 2018.

One of two sculptures partially recast as part of the Allée restoration in 2012. This and other sculpture casting on the property were done by Skylight Studios in Woburn, Massachussetts.

Tree removal during the Allée restoration, 2012.

paper—is a top priority. Important primary documents, including a 1949 house inventory, 1930s photos, the 1950 auction catalog, and 1928 furniture inventory photos assembled by David Adler, have provided curators with a historic record of the original furniture and art. These documents have guided curators in placing furnishings and art where they once lived when the family summered here.

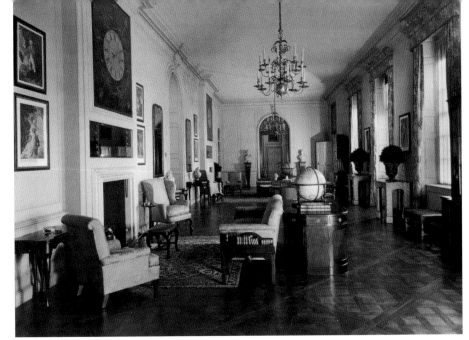

Interior photographs taken in ca. 1931 by Mattie Edwards Hewitt compare with a contemporary shot of the same room, as restored by The Trustees. The photos appear in a 1935 issue of *Town & Country* magazine, accompanying an article by Augusta Owen Patterson.

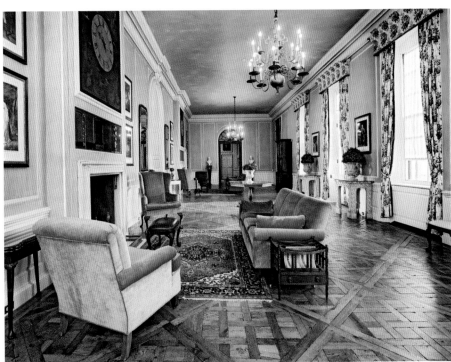

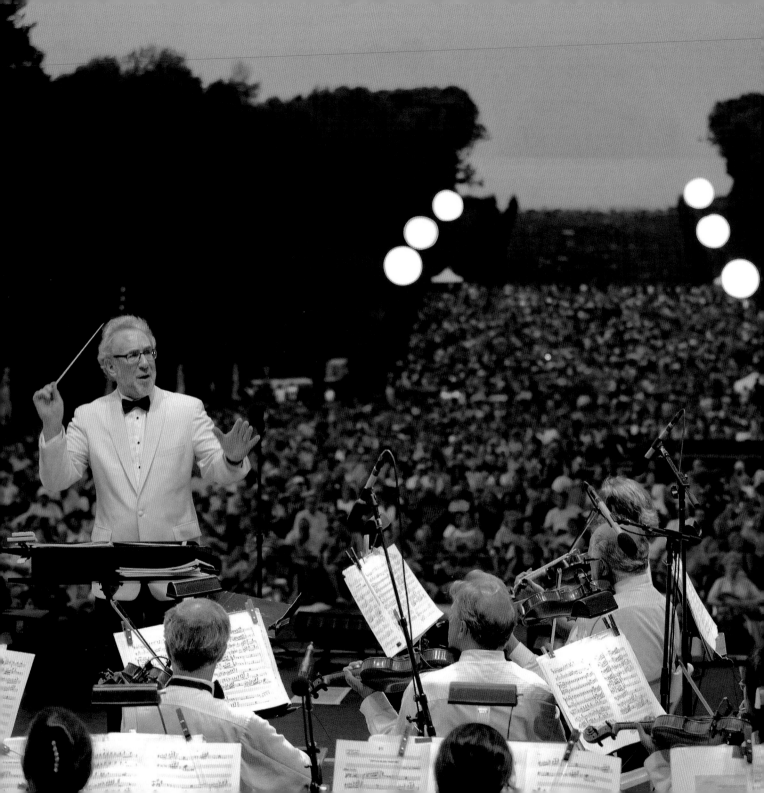

CASTLE HILL TODAY

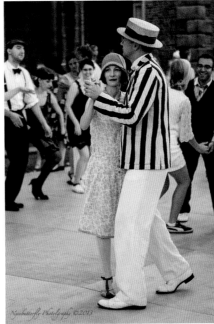

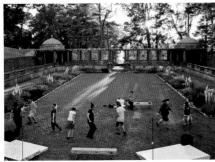

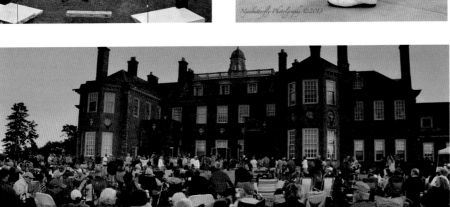

The Trustees' diverse programming at Castle Hill strives to capture its unique combination of nature and culture.

Today's visitors can enjoy house tours, theatrical performances, outdoor concerts and dance parties, as well as nature walks, children's summer camps, and much more.

Opposite: Summer concert with the Boston Pops on the Grand Allée, in celebration of The Trustees' 125th Anniversary in 2016.

Clockwise: "Guest of the Cranes" tour guides take on the role of Crane staff in 1929; scene from a "Roaring 20s" Lawn Party; a picnic concert; a Commedia dell'arte rehearsal in the Italian Garden.

ARCHITECTS, LANDSCAPE ARCHITECTS, AND ARTISTS AT CASTLE HILL

DAVID ADLER (1882–1949): A Chicago architect who designed elegant houses for the social elite. After graduating from Princeton, he attended the Polytechnikum in Munich and the École des Beaux-Arts, Paris. Adler's classic yet eclectic style drew upon his extensive architectural library, employing Italian, Spanish, French, and English tastes among the more than forty estates attributed to him. For the Cranes, he designed their winter house on Jekyll Island, Georgia (1916); their summer mansion and gate lodges in Ipswich (1924–28); and an altar dedicated to Mr. Crane at St. Chrysostom's Church, Chicago (1948).

ERNEST BOWDITCH (1850–1918): An MIT-trained engineer and landscape architect, Bowditch took over the practice of Robert Morris Copeland in the 1870s. He is credited with more than 2,500 public and private projects, and is known for his use of curvilinear road schemes and mass plantings to enforce views and road edges. Hired by John B. Brown for Castle Hill Farm, it is his road system that is largely extant today.

EDWARD BURNETT (1849–1925): Edward Burnett worked in the design and management of large-scale agricultural operations. He was hired as a design team consultant for the farm buildings at Castle Hill and worked in cooperation with Shepley, Rutan & Coolidge. Early in his career he managed the farm estate at Biltmore in Asheville, North Carolina.

HARRIETT RISLEY FOOTE (1863–1951): A rosarian who worked often with landscape architects and designers, her background as a scientist led her to experiment with cultural techniques, including deep soil penetration, minimal pruning, and heavy feeding, to produce large, heavy-blooming specimens. Mrs. Foote's own four-acre property in Marblehead, Massachusetts, boasted some 10,000 specimens of roses.

THE OLMSTED BROTHERS (1898–1961): The successor firm to Frederick Law Olmsted (famous for New York City's Central Park and Boston's Emerald Necklace), operated by Olmstead's son and stepson. The most well-known landscape architects of the period, they continued their father's tradition of designing public parks and college campuses but became best known for estate and garden designs. Their tenure on the Crane estate was 1909 to 1912.

BELA PRATT (1867–1917): Renowned American sculptor whose work is prominent in the Boston area, including public monuments of intellectual figures such as Boston Symphony Orchestra Founder Henry Lee Higginson (1902) and Edward Everett Hale (1913), as well as the pair of allegorical figures of *Art and Science* at the Boston Public Library (1912). His mentor for nearly twenty years was Augustus Saint-Gaudens (1848–1907). Pratt also headed the sculpture department at the School of the Museum of Fine Arts.

PAUL MANSHIP (1885–1966): A prominent and prolific sculptor in his own time, today he is best known for his Art Deco *Prometheus* at New York's Rockefeller Center (1934). His streamlined classical forms helped initiate the Art Deco style, and he was a frequent collaborator on architectural projects. Manship designed the pair of *Griffins* on the north terrace of the Great House, which was a 1928 gift to Mr. Richard T. Crane, Jr., from 3,600 former employees of Crane Co.

JOHAN SELMER-LARSEN (1876–1969): Originally from Norway, Selmer-Larson settled in Boston in 1906. He was hired by the Olmsted Brothers in 1912 and would continue to work with them for more than forty years, modeling and sculpting works for their garden commissions. He also taught at the School of the Worcester Art Museum and at MIT.

SHEPLEY, RUTAN & COOLIDGE: One of the successor firms of Henry Hobson Richardson (1838–1886), the premier American architect of the late nineteenth century. This Boston firm also designed the Crane's primary residence on Lake Shore Drive, Chicago. Some of their best-known commissions include The Art Institute of Chicago, University of Chicago, and Boston's Ames Building, among others. The firm currently practices under the name Shepley Bulfinch Richardon and Abbott.

ARTHUR SHURCLIFF (1870–1957): Engineer and landscape architect who was mentored by Charles Eliot, worked for the Olmsted firm in Brookline, and in 1899 founded, with Frederick Law Olmsted, Jr., the nation's first four-year course of landscape architecture at Harvard. He opened his own practice in Boston in 1904. He is well known for his work as chief landscape architect for the restoration of Colonial Williamsburg (1928–41).

LANDSCAPE MAP

Key

1 The Great House

2 Terrace, Tennis Court / Bowling Green

3 Grand Allée and Statuary

4 Log Cabin Site

5 Italian (Formal) Garden

6 Rose Garden

7 Woodland Trail and Pivot Rock

8 Chauffeur's Residence and Garage

9 Casino Complex

10 The Brown Cottage / The Inn at Castle Hill
and Tavern

11 Gate and Lodges

12 Farm Complex

13 Vegetable Garden and Towers

14 Reservoir

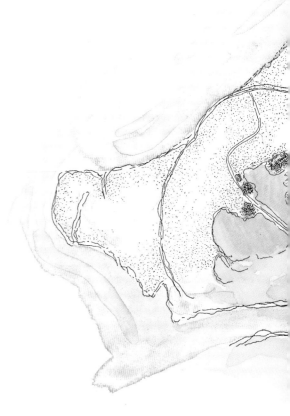

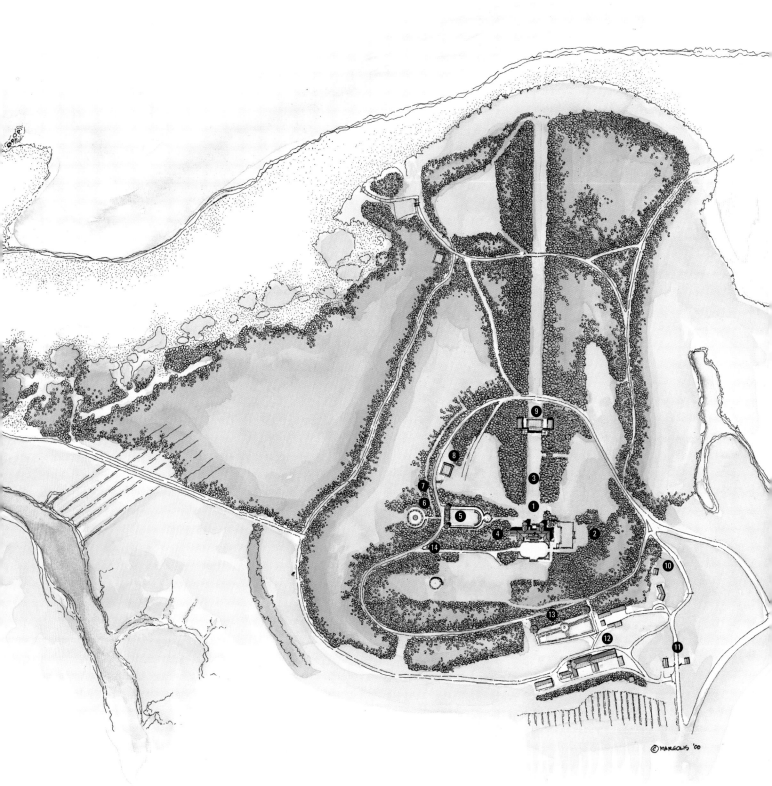

©MARGOLIS '00

Acknowledgments

Written by Anna Kasabian with additional text and research by Susan Hill Dolan, Curator, Trustees Ipswich Properties, and Danielle Steinmann, Trustees Director of Visitor Interpretation. Special thanks to the staff of Castle Hill on the Crane Estate, the Trustees Archives and Research Center, and members of the Trustees marketing and curatorial staff who contributed to this project.

Photographic Credits

Unless otherwise indicated, all images are from The Trustees Archives and Research Center.

Above Summit: p. 6; Art Institute of Chicago Ryerson and Burnham Library: p. 22; Jay Burnham/North Shore Drone Service: pp. 12–13; Robert Cameron collection: p. 49 (top); Terry Cook: p. 59 (top left and bottom); Paul Dahm: p. 42 (bottom left); Susan Hill Dolan: p. 55; Mark Gardner: front cover and pp. 16, 20; Gross & Daley Photography: pp. 44, 46–47, 50 (top right), 52 (bottom), 59 (middle left); Jumping Rocks: inside front cover, back cover, and pp. 4, 18–19, 26, 30, 34 bottom (left and right), 35 (top and bottom right), 42 (bottom right), 52 (top); David Kasabian: pp. 2, 24, 27, 29, 31, 34 (top), 57 (bottom); Tom Kates: back cover, p. 9; Lake Forest College, Donnelley and Lee Library: p. 57 (top); Robert Murray: p. 42 (top); Courtesy of the National Park Service, Frederick Law Olmsted National Historic Site: p. 50 (bottom); Nycebutterfly: p. 59 (top right); Ciara O'Flynn: p. 54; B. Staples: p. 56; Joe Staska: pp. 17, 28, 41, 43 (top and bottom left); Winslow Townson: p. 58; Stephanie Zollshan: p. 50 (top left)

Text and photography ©2020 The Trustees

Book ©2020 Scala Arts Publishers, Inc.

First published in 2020 by
Scala Arts Publishers, Inc.
c/o CohnReznick LLP
1301 Avenue of the Americas
10TH floor
New York, NY 10019
www.scalapublishers.com
Scala · New York · London

Distributed outside of The Trustees in the book trade by
ACC Art Books
6 West 18TH Street
Suite 4B
New York, NY 10011

ISBN 978-1-78551-254-4

Cataloguing-in-Publication Data is available from the Library of Congress. Identifiers: LCCN 2020035577 | ISBN 9781785512544; Classification: LCC F74.I6 T78 2020 | DDC 974.4/5−dc23 LC record available at https://lccn.loc.gov/2020035577

Edited by Susan Higman Larsen
Designed by Patricia Inglis, Inglis Design
Printed and bound in China

10 9 8 7 6 5 4 3 2 1